Porch Dogs

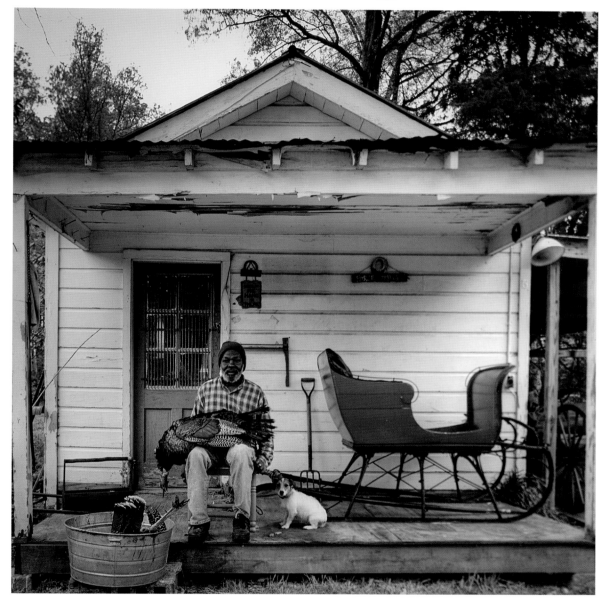

Biscuit pretends to help the turkey plucker, but he's actually planning to dig a big hole and bury that other winged creature.
MEMPHIS, TENNESSEE

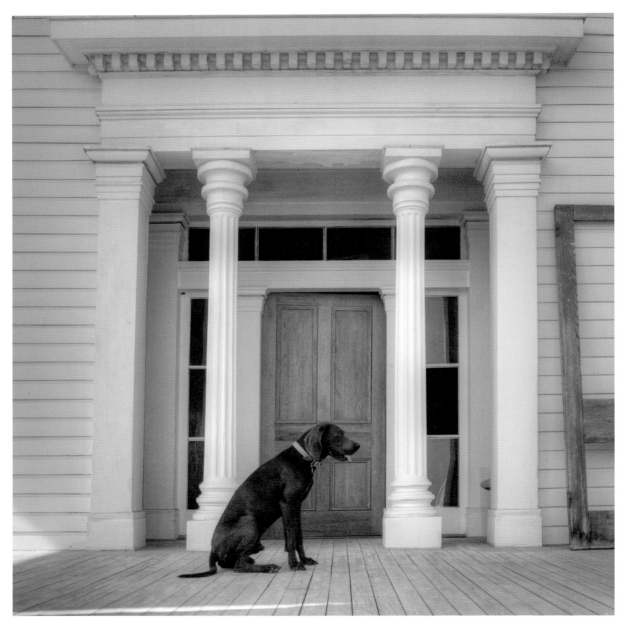

Red has kept vigil ever since he found out his house almost burned to the ground during the Civil War. You never know when trouble might come knocking.

HOUSE CIRCA 1859 / BENOIT, MISSISSIPPI

Porch Dogs

NELL DICKERSON
FOREWORD BY ROBERT HICKS

JOHN F. BLAIR, PUBLISHER
Winston-Salem, North Carolina

JOHN F. BLAIR,
PUBLISHER
1406 Plaza Drive
Winston-Salem, North Carolina 27103
www.blairpub.com

Printed and bound in China by Four Colour Print Group

Photography and text by Nell Dickerson
Photographs: Copyright 2012-2013 by Nell Dickerson
http://nelldickerson.com

Library of Congress Cataloging-in-Publication Data

Dickerson, Nell.
 Porch dogs / by Nell Dickerson ; foreword by Robert Hicks.
 pages cm
 Includes index.
 ISBN 978-0-89587-597-6 (alk. paper) — ISBN 978-0-89587-598-3 (ebook) 1. Photography of dogs. 2. Dogs—Southern States—Pictorial works. 3. Porches—Southern States—Pictorial works. I. Title.
 TR729.D6D53 2013
 779'.475—dc23
 2012034226

10 9 8 7 6 5 4 3 2 1

For Nunny

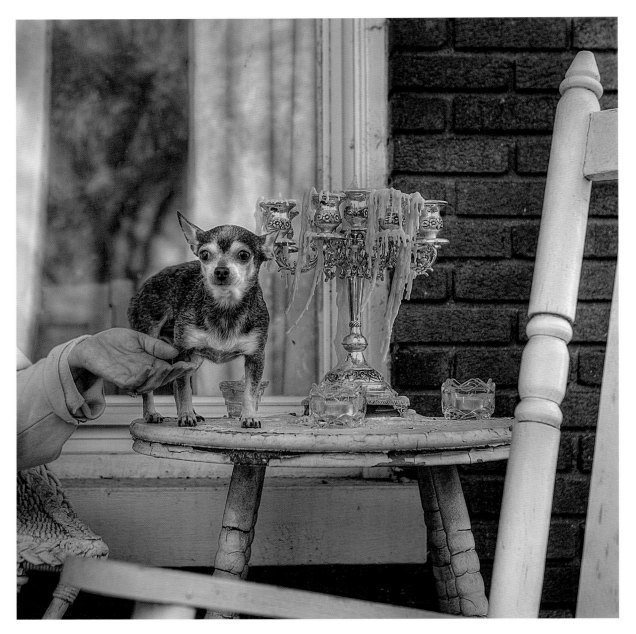

Mr. B's favorite time is after the party, when he eats the leftovers.
CLARKSDALE, MISSISSIPPI

Contents

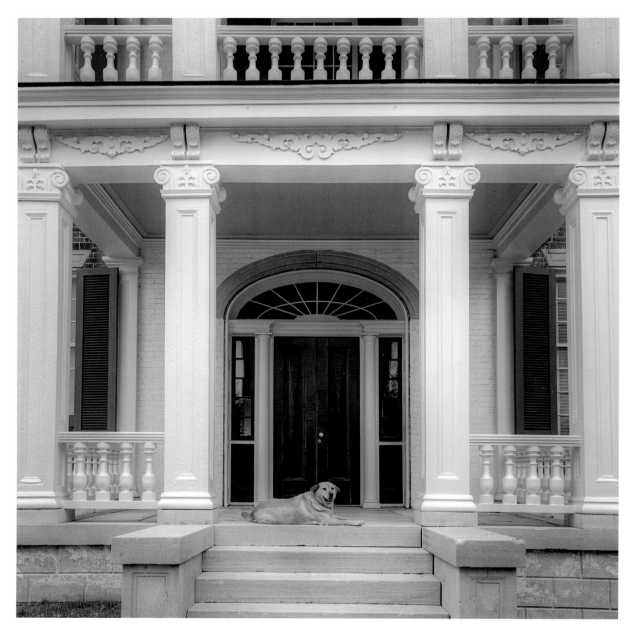

Jake greets visitors to historic Carnton Plantation, which was a field hospital during the Civil War Battle of Franklin. Carnton, now a museum, served as the backdrop for the novel *The Widow of the South*.
HOUSE CIRCA 1826 / FRANKLIN, TENNESSEE

Foreword

I come from "dog people" who come from "dog people" who come from "dog people." That's as far back as I can document my passion for dogs. But I have a feeling that just as my grandmother could link the family back to 1066, even if she had to skip a generation or two to get us there, my people have always loved dogs and have never been shy about letting others know it.

Truth is, Southerners probably don't love their dogs any more than folks in the Midwest or the Northeast or anywhere else. My theory is that we're just more demonstrative in our love— that we're missing whatever gene it is that steers others away from open and unbridled expression of canine passion.

My dog is named "Jake, The World's Greatest Dog." That's his full name. Regularly, folks hear his name and tell me their dog could give Jake a run for his money. Then they meet him and within a few minutes start backing off, telling me their dog is "*one* of the world's greatest dogs."

What Jake happens to be is the sweetest dog I've ever known. Not that Banjo, Salem, and all who came before him weren't sweet dogs. It's just that he lives up to his billing. Part of being The World's Greatest Dog is that Jake really doesn't care about all the hoopla that surrounds him. Mostly, he is just about being a dog and loving all living-kind.

I had his DNA tested a few years back and found he is half Rhodesian Ridgeback, one-eighth Chow, one-eighth Pit Bull, one-eighth Golden, and one-eighth Lab. It would seem that all the parts came together to make for a fine dog engineered to spend much of his life on or around the porch.

I guess that's why I was asked to write this foreword . . . because of Jake. Of course, it didn't hurt that I love this book and Nell Dickerson's handsome photographs. I can't think of a better way to celebrate and honor the love of dogs than through Nell's lens.

People often speak of an artist as having a "painterly" vision of his or her world—of having the ability to see surroundings as others never will. Nell's passion for and connection with dogs of all shapes and sizes—whether on porches or verandas, in the yard, or on docks— shine through. While some of her images are of handsome beasts, some of the dogs are long past their prime, reminding us that love knows no boundaries.

I could go on and on about Nell's talent as a photographer, but the images speak for themselves. In witnessing her love of dogs, we have been invited to join in a celebration almost as old as mankind.

Speaking for Jake and myself, we are honored to be part of Nell's celebration.

Robert Hicks

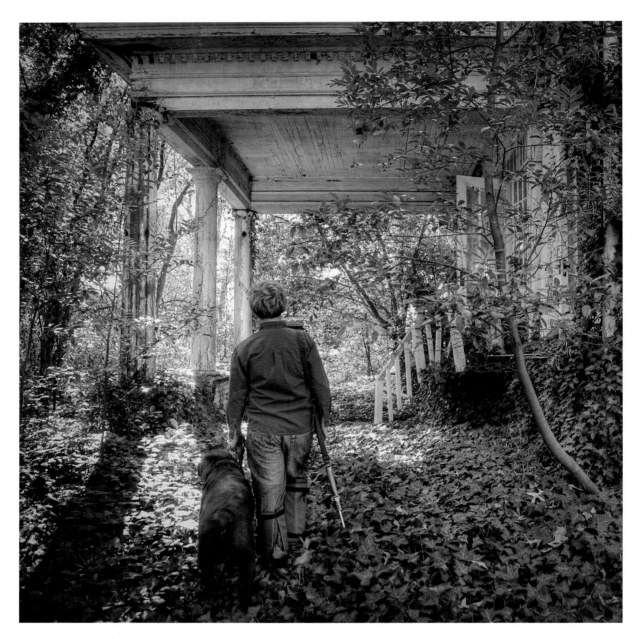

Luke goes on safari, where mysterious adventures lurk in the ivy.
HOUSE CIRCA 1880 / FRIARS POINT, MISSISSIPPI

Sentinels of the South

*I*f the Civil War crippled the South, then air conditioning finished it off.

There was a time when every significant life event in the South occurred on the porch. People visited with each other, courted, conducted important business, ate summertime meals, cleaned guns and boots, shelled butter beans, watched fireflies, and listened to crickets while gazing at the star-filled sky.

People in the South lived on the porch because it was hot. When air conditioning came along, folks retreated indoors to get relief from the heat. As a result, they lost interest in outdoor rooms.

Porch sitting, one of the most significant pastimes of Southern culture, has since gone the way of hand-churned ice cream and the quilting bee.

I remember my grandparents' two screened porches on their house in the Mississippi Delta. The family visited together and drank iced tea on the downstairs porch. We slept on the upstairs porch. The sleeping porch was an adventure because we could sleep outside and mosquitoes did not torture us. The night noises—katydids, cicadas, and tree frogs—and the cool breeze from the overhead fan lulled me to sleep. I loved to be there during summer rainstorms. Rain smell, drops hitting the tin roof, and lightning all made for vivid dreams.

During the day, when the heat and humidity became unbearable, we sought sanctuary inside the house. The family dog—content to stay outside—continued his vigilance, watching all and nothing. I felt like he understood that the porch was the gateway between inside and outside and that it was his duty to keep sentry there in case someone wanted to pass.

Later, as an adult, I noticed that few new houses had porches. Architects quit designing them, and contractors quit building them. People no longer needed porches because they preferred to isolate themselves indoors in the air conditioning. Many of our dogs had no

place from which to watch the world.

I mourn the loss of this vital aspect of the South's architectural and cultural history. We Southerners used to be social. Now, we risk losing what makes us Southern: porch sitting.

There is hope. Our dogs maintain the tradition.

When I began my artistic journey as a photographer, I observed that most buildings had porches, and almost every porch had at least one dog on it. Each person I met received me on the porch.

I now want to preserve our porches for our dogs.

For eight years, I traveled the Deep South to photograph dogs on porches. Most of the time, the dogs' humans made the introductions. When that happened, we sat on the porch and visited just like in my childhood—people and dogs together—until the time was right to make the portrait.

We did not always sit on a traditional porch. A dog will make a porch out of any place where he can keep cool, watch, and snooze. Some canines insist that their people be integral parts of their watch, while others prefer to hold vigil alone. Sometimes, a lonely dog found me as I wandered, looking for a photograph.

I discovered some universal truths as I made this photographic expedition: People from all over the United States are nostalgic for porches and the social interactions that occurred on them. The porch is a unique American architectural element. Porch sitting is an American pastime. Dogs sit on porches throughout the nation. And most important, Americans love dogs.

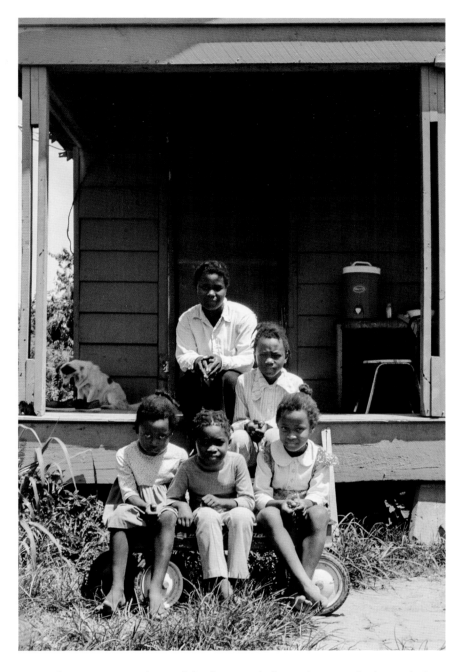

These five sisters sit in front of the first porch dog I photographed. I took this picture in 1976 on my grandparents' Mississippi Delta farm.

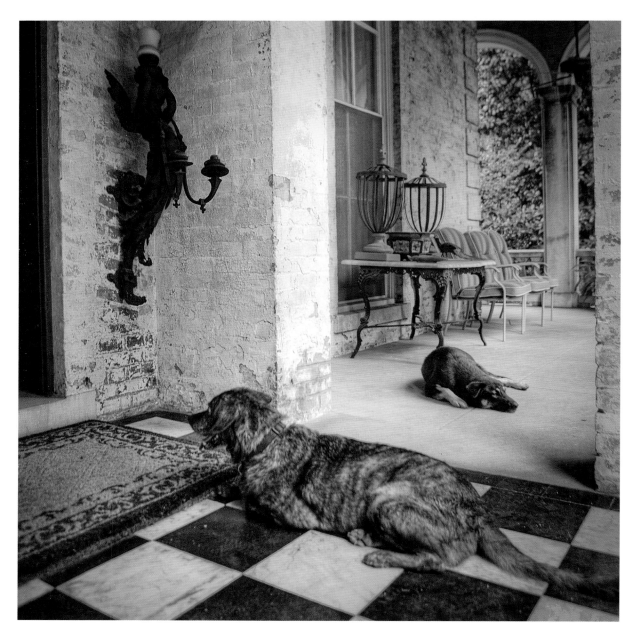

Sparky prefers to be on the other side of the door, no matter which side he is on. Blackie is content to always be on the right side.

House circa 1850 / Memphis, Tennessee

House Dogs

OST DOGS LIVE WITH PEOPLE, and people tend to live in houses. If a house has a porch, then that's where the dog prefers to be.

House dogs are territorial because the porch is the gateway between inside and outdoors—the best of both worlds. House dogs are sentries. They grant permission to any intruder (dog, cat, human, etc.) to pass through the magic portal of dual universes.

Cleopatra is the Mardis Gras queen because she has the most beads. Another parade will come by soon.
Nᴇᴡ Oʀʟᴇᴀɴs, Lᴏᴜɪsɪᴀɴᴀ

House Dogs

Ogre guards the porch chairs in case they try to rock away.
House circa 1909 / Hernando, Mississippi

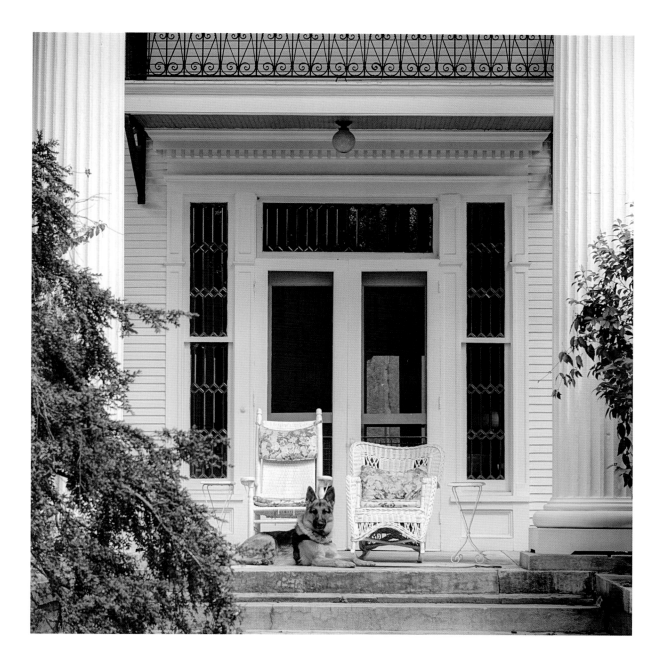

House Dogs

Maggie and BB discuss what to do with the caged bird. It sure would be fun to let it out, wouldn't it?

Housᴇ ᴄɪʀᴄᴀ 1855 / Cʜᴀʀʟᴇsᴛᴏɴ, Sᴏᴜᴛʜ Cᴀʀᴏʟɪɴᴀ

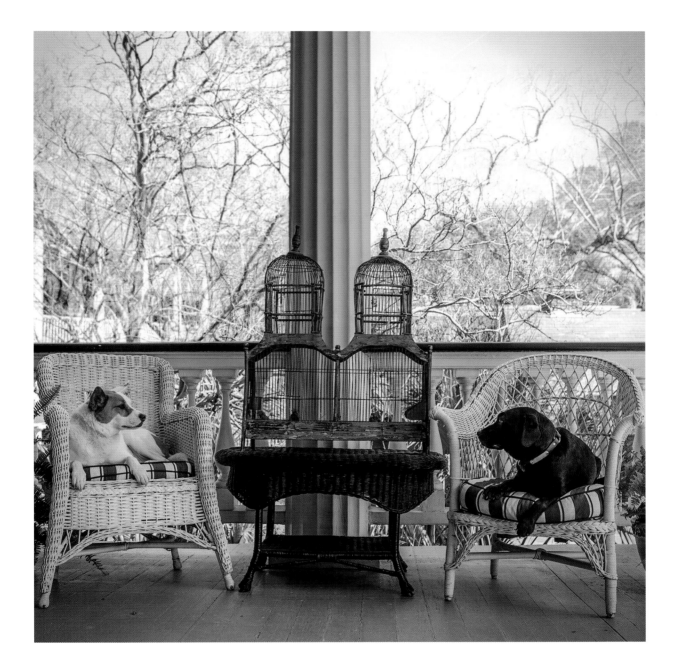

House Dogs

Sisters Millie and Belle take tea for two at Sedgewood, one of the few antebellum houses left in their county.

HOUSE CIRCA 1842 / CANTON, MISSISSIPPI

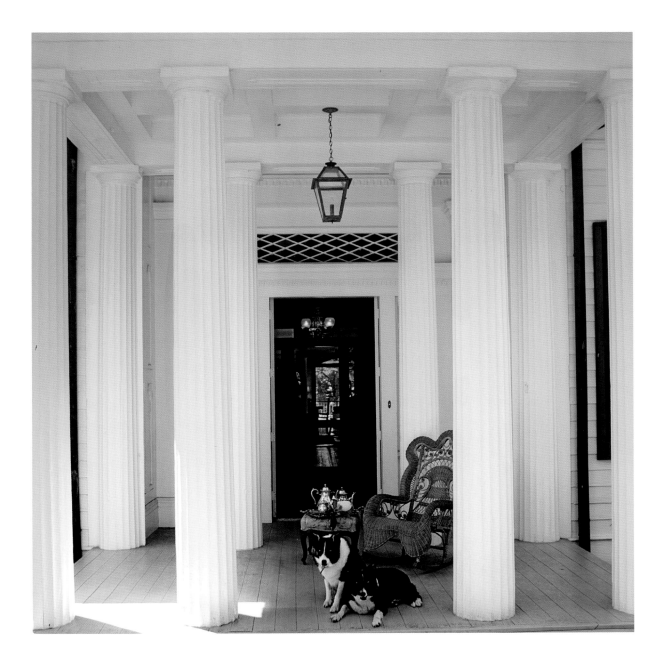

House Dogs

Biscuit drives the pony cart pulled by Potato. At this rate, it might be faster to jump down and run ahead.

House circa 1948 / Memphis, Tennessee

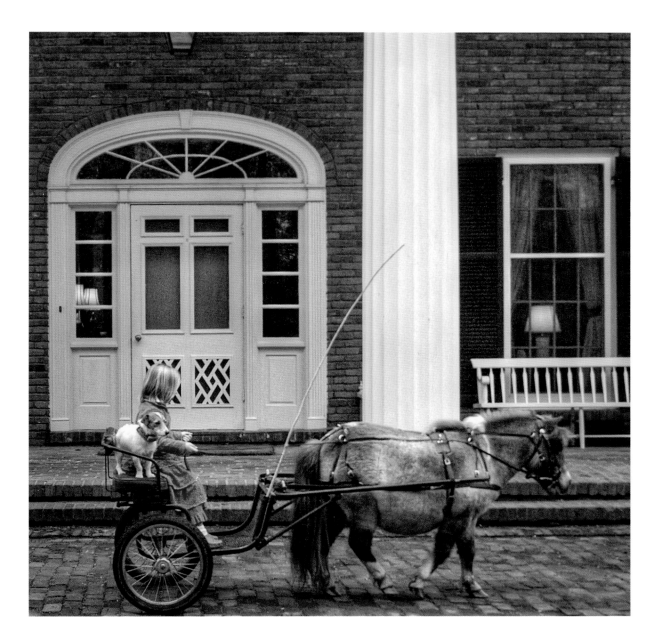

House Dogs

Hound Dog expects at least a steak for this grin. The bigger the smile, the better the treat.

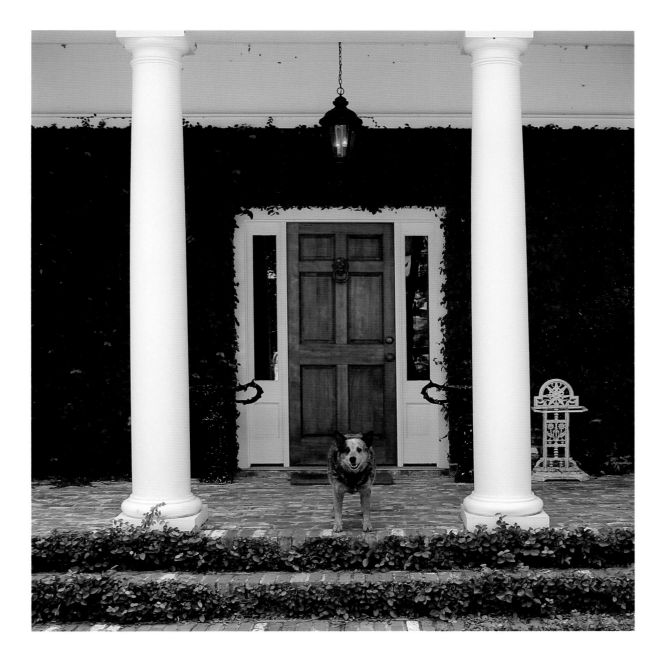

Memphis is a "gun dog" because the gun cannot hunt without her. It's up to Memphis to nose, search, point, and retrieve. What good is that gun without a dog?

HOUSE CIRCA 1795 / BINGHAM, TENNESSEE

BOCK DOPPELFLINTE SHOTGUN CIRCA 1956 BY MERKEL SUHL, GERMANY

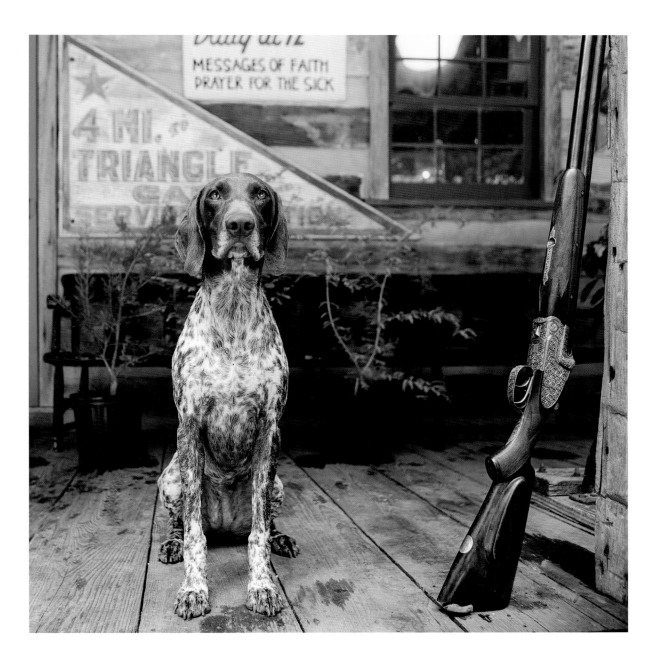

House Dogs

Carmen's home, Walter Place, saved her town from fire during the Civil War because General Grant hid his wife here. Carmen is glad to be the lady of the house now.

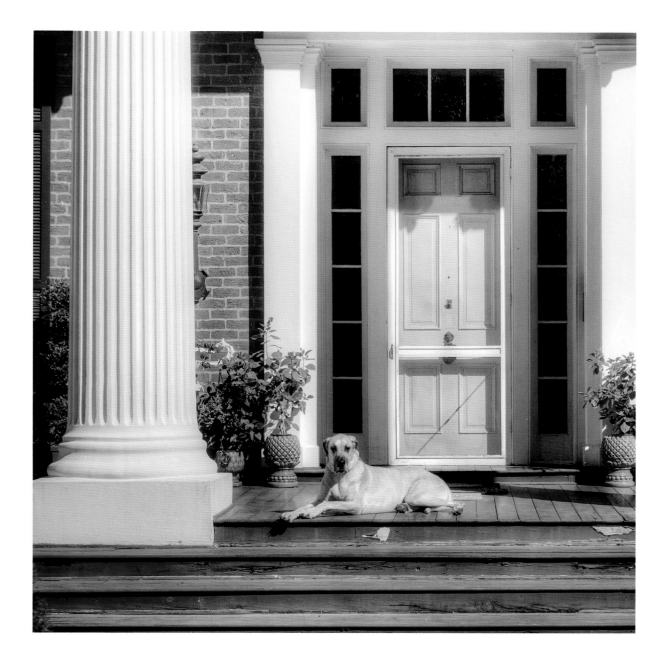

House Dogs

19

Callie lives on a rural highway, where she watches cars go by all day. Occasionally, she traps a tourist so she has something to herd.
COVINGTON COUNTY, ALABAMA

Roxie and Barkley show their guest how to do some serious rocking at Windermere, the historic plantation next to Carnton.

HOUSE CIRCA 1875 / FRANKLIN, TENNESSEE

Nike does not understand why she has to take a bath. As soon as she gets free, she's going to chase those chickens again and maybe roll in the dirt just for fun.

<small>Barnwell, Alabama</small>

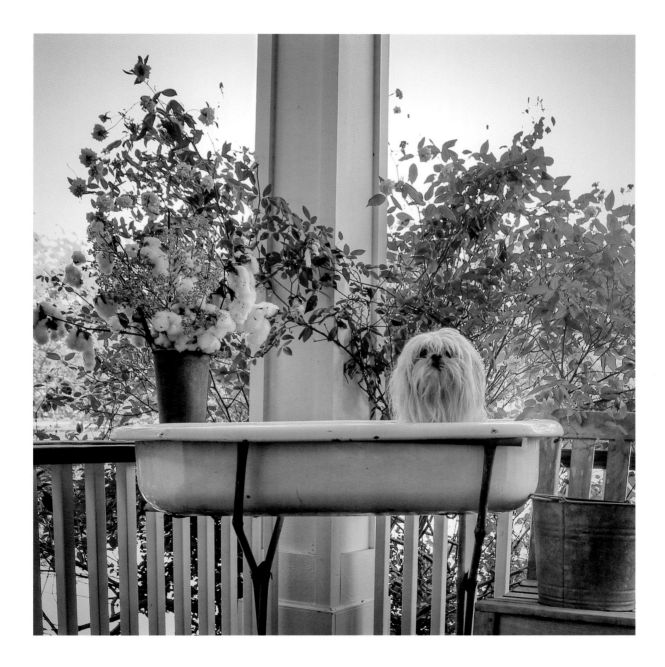

House Dogs

Ray got a baby duck for Easter. "It's mine," he says, but no one listens.
HOUSE CIRCA 1910 / GREENWOOD, MISSISSIPPI

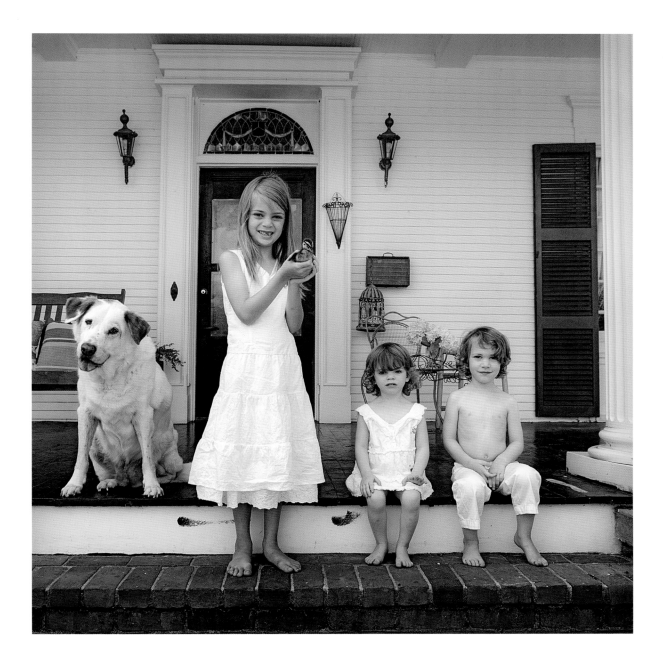

House Dogs

25

Annie and Jesse find it curious that all those other Dachshunds never move.
HOUSE CIRCA 1896 / DEFUNIAK SPRINGS, FLORIDA

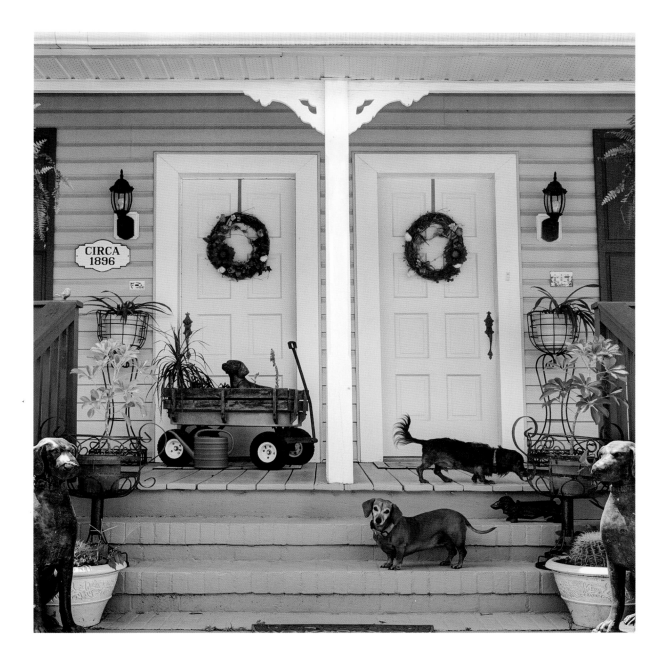

House Dogs

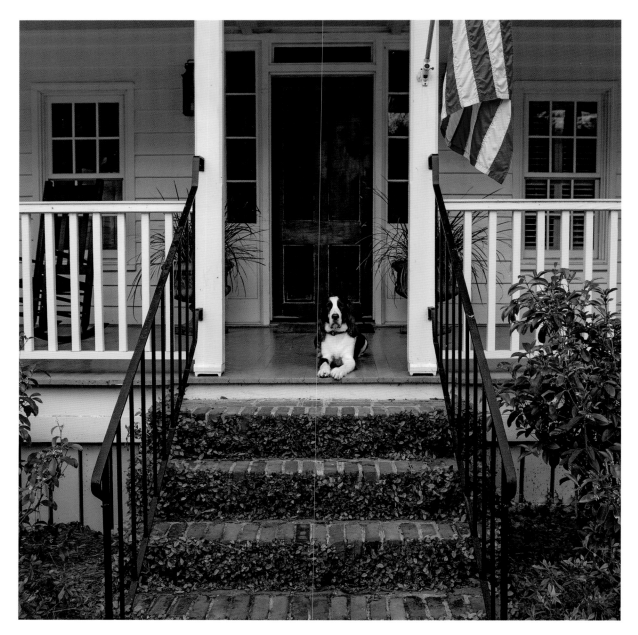

Bailey watches for approachers. Her family throws oyster shells in the driveway. They told her all of the original streets in their village were paved with broken shells. No oyster is going to sneak up on her.

House circa 1910 / Mount Pleasant, South Carolina

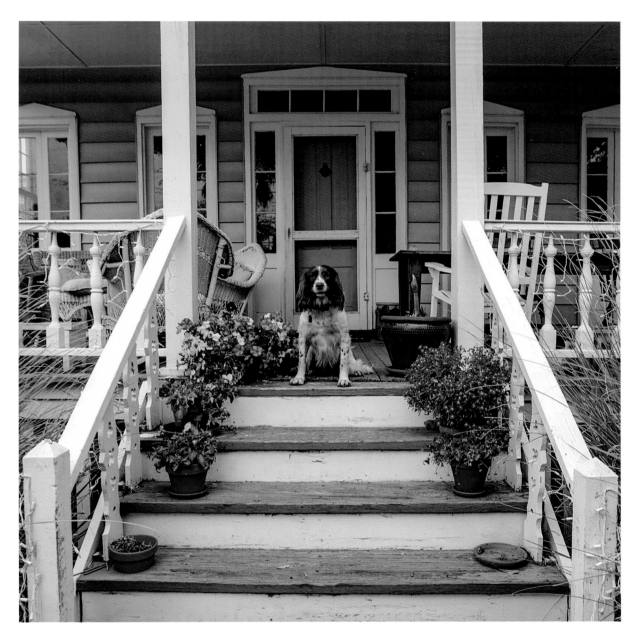

Daisy keeps sentry on an island that has been protecting Charleston Harbor since 1776, when the Americans achieved what some consider their first major victory over the British in the Revolutionary War.
HOUSE CIRCA 1880 / SULLIVAN'S ISLAND, SOUTH CAROLINA

Harvey loves to go fishing. Why bother with all that gear when you can jump in the water and catch fish with your teeth?

Point Clear, Alabama

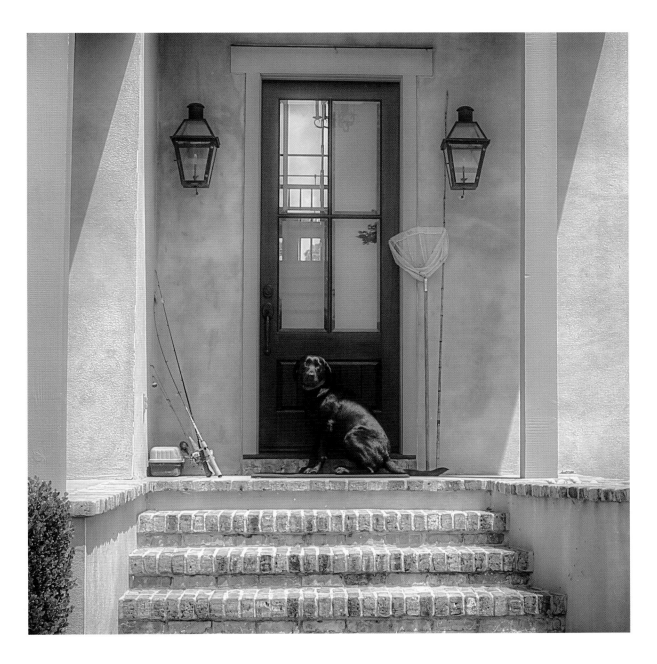

House Dogs

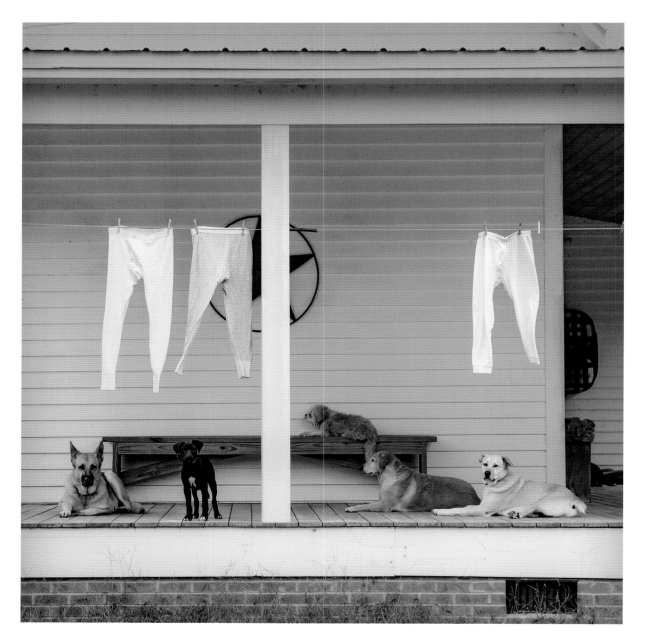

Gretel leads a pack of rescues. She shepherds the new puppy, Lucy, into the fold while Oscar, Betsey, and Scout approve.

House circa 1910 / Meansville, Georgia

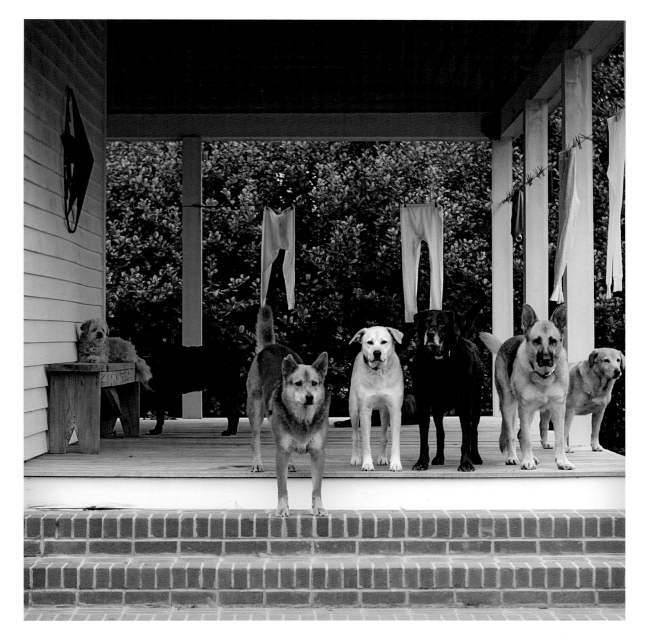

Oscar and Noble hang back while Bailey, Scout, Train, Gretel, and Betsey inspect an intruder. Dinah lies down behind them.

House circa 1910 / Meansville, Georgia

Teeny Baby relaxes on Sarge's patriotic porch.
HOUSE CIRCA 1925 / NATCHEZ, MISSISSIPPI

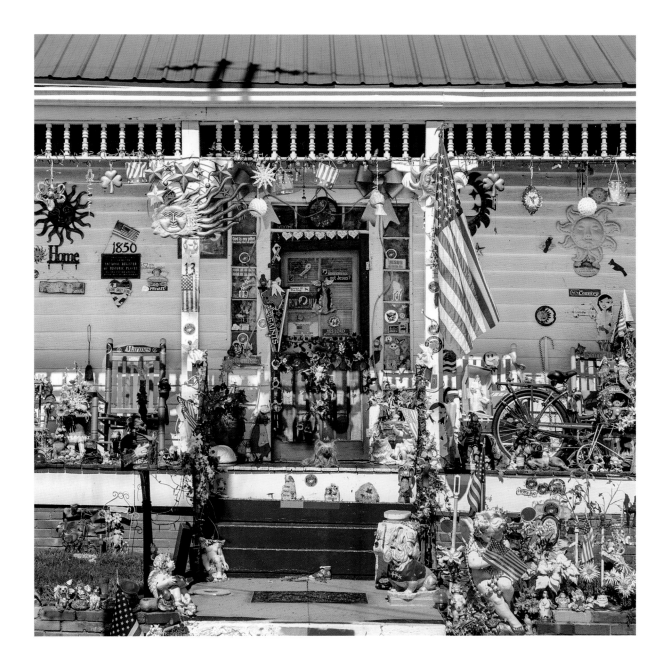

House Dogs

Barney figured out that since he has a leg in each corner, two legs are better than none. He uses a cart to keep up with his pack.

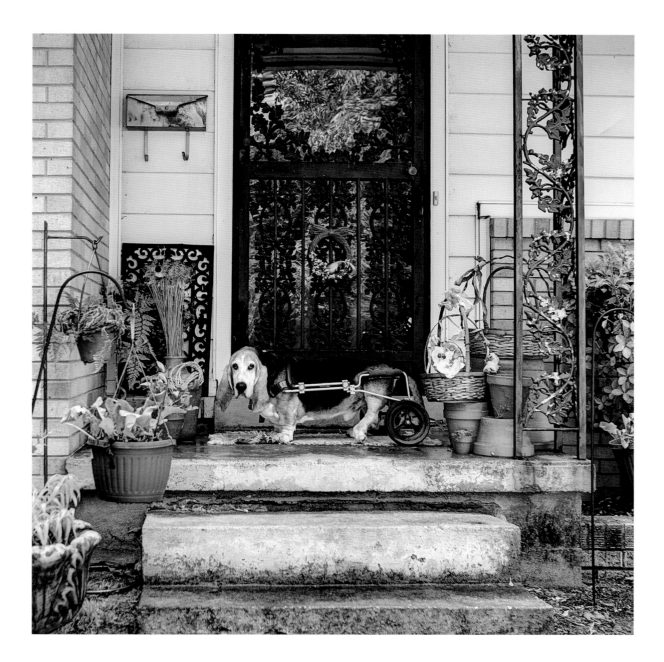

House Dogs

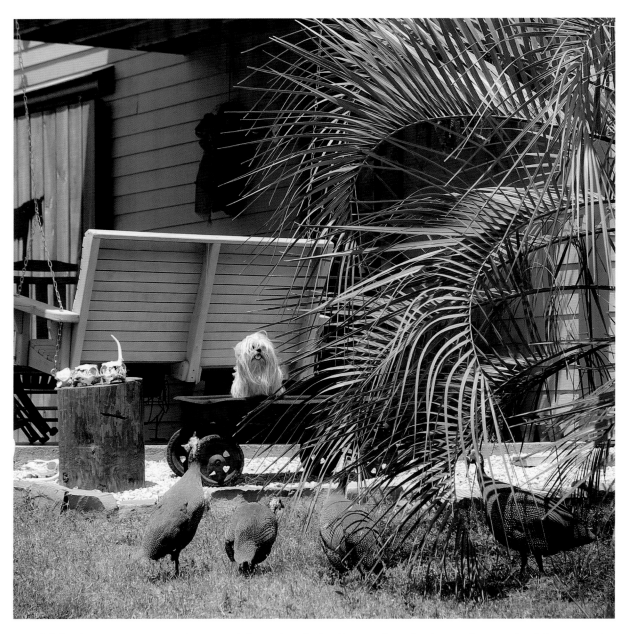

Randolph plans to spring into the air and chase that flock of guinea hens back into the woods. If she succeeds, they won't come back for a week.
MAGNOLIA SPRINGS, ALABAMA

Yard Dogs

The action is outdoors. Yard dogs chase squirrels, birds, night critters, and other intruders. They love to hunt anything that moves or smells. They also savor the garden scent, roll in the grass, and investigate peculiar organic matter.

Muffin and Biscuit live in a paradise with no boundaries and an endless supply of mischief to entertain them.

Yard Dogs

Gracie goes on a backyard cruise.

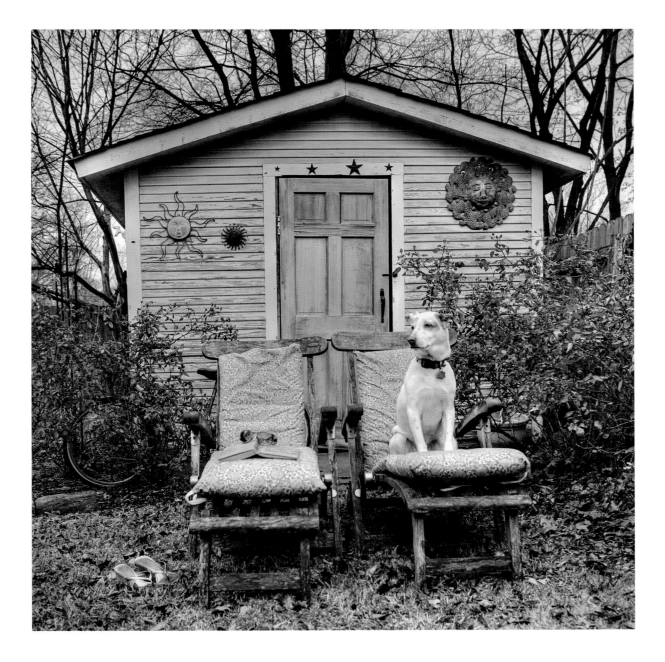

Yard Dogs

Oliver receives guests at an inn on a secluded island filled with wild horses, feral hogs, marsh birds, deer, and other creatures of the live oak and palmetto woods.

House circa 1900 / Cumberland Island, Georgia

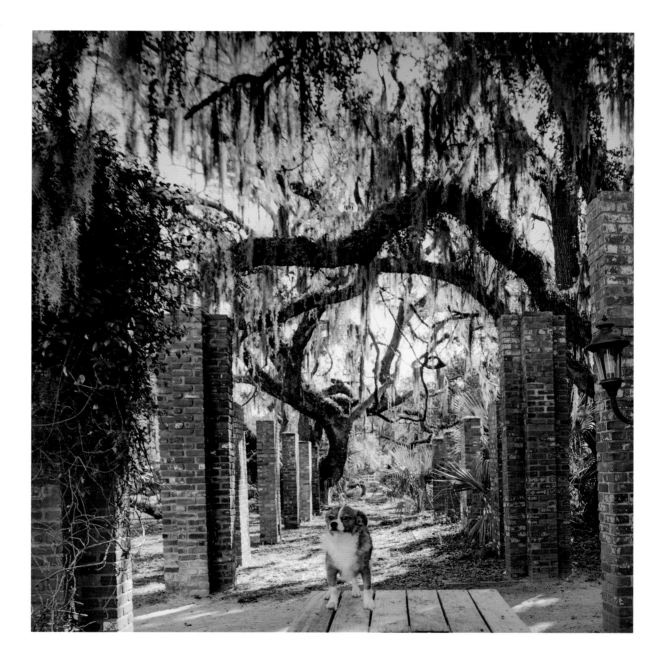

Yard Dogs

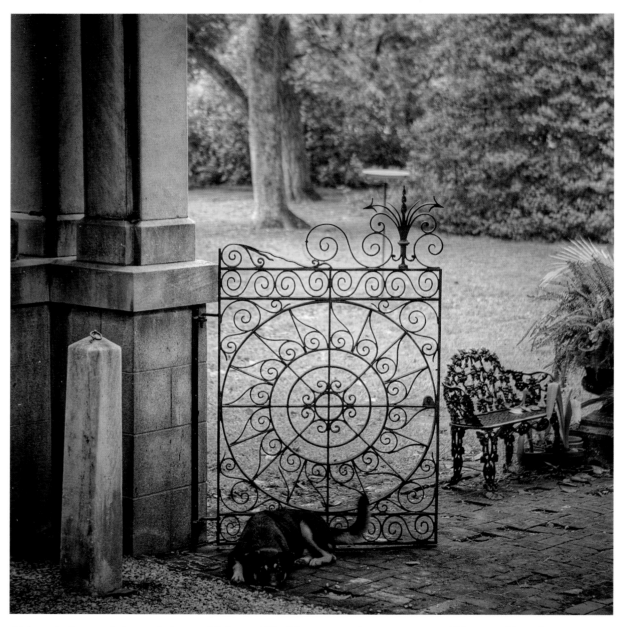

Although the porch is good, the yard is better. Blackie protects the gateway to a 150-year-old garden.
HOUSE CIRCA 1850 / MEMPHIS, TENNESSEE

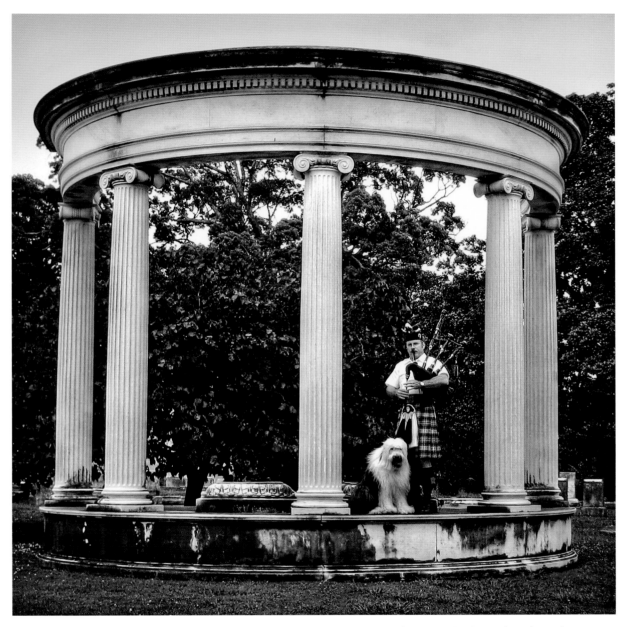

Sam leads a bagpiper on a stroll throughout a cemetery. They pause at the central colonnade, where the melody resonates in all directions.

CEMETERY ESTABLISHED 1852 / MEMPHIS, TENNESSEE

Riley knows better than to swim in the fountain, but he can't help it if his toy fell in.

House circa 1850 / Charleston, South Carolina

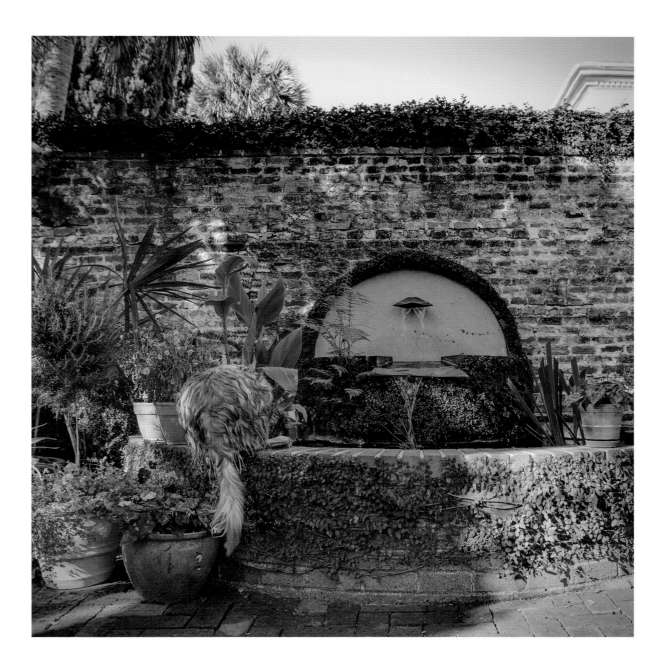

Yard Dogs

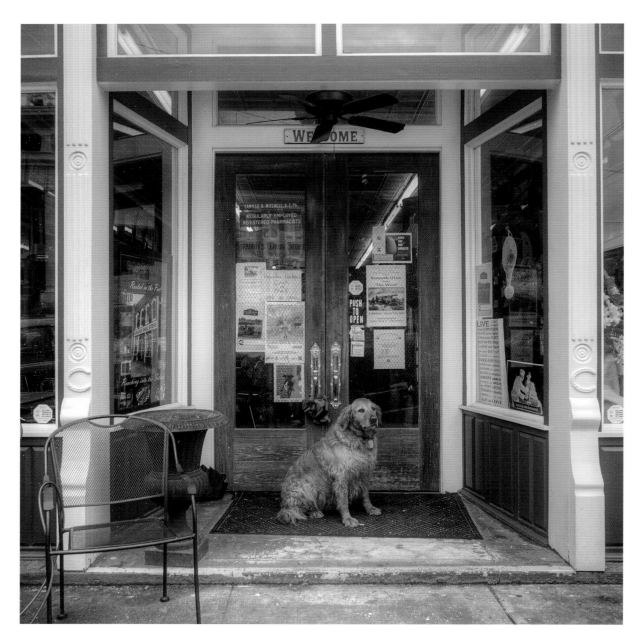

"Shiloh," who has the run of downtown, greets patrons at a drugstore established in 1865. I nicknamed her after the nearby Civil War national battlefield park.
BUILDING CIRCA 1843 / CORINTH, MISSISSIPPI

Shop Dogs

Some dogs prefer to go to town. Commercial porch dogs are exhibitionists. They sit in shop windows or hang out on storefront stoops. All of those passing people and cars offer much to watch. It's also fun to trot after customers and turn on the big puppy-dog eyes for extra attention.

Sushi welcomes patrons to a rare-book and document gallery located in a historic village founded on a Revolutionary War land grant.
Building circa 1881 / Leiper's Fork, Tennessee

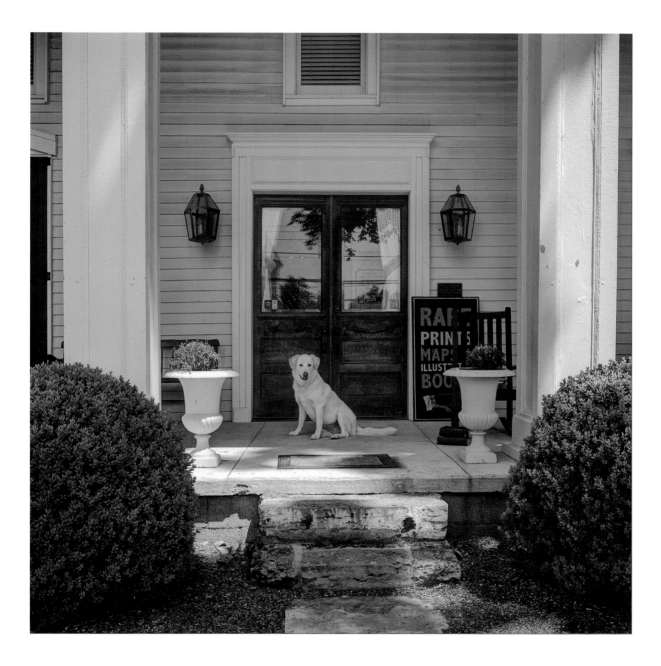

Shop Dogs

Prince and Lolita meet antique collectors in a railroad town founded on one of only two perfectly round lakes in the world.
DeFuniak Springs, Florida

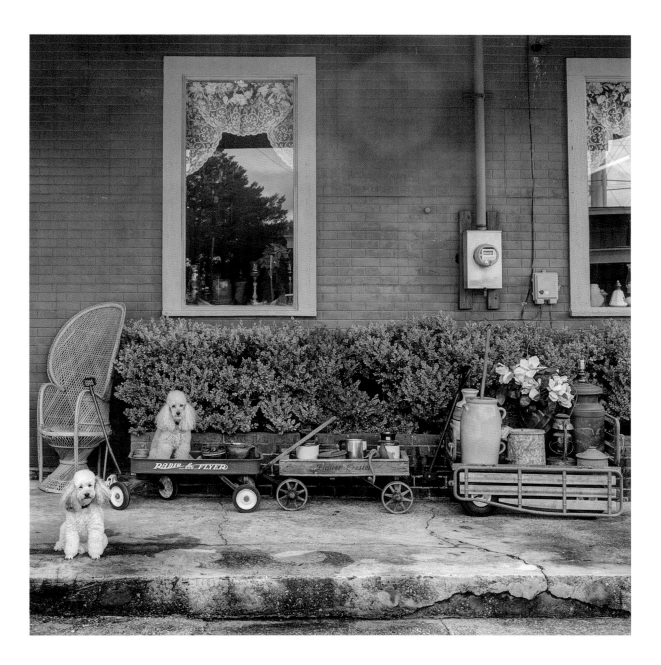

Shop Dogs

Butters surveys downtown shoppers from his window seat in an art gallery. Sorry, he's not for sale.

NATCHEZ, MISSISSIPPI

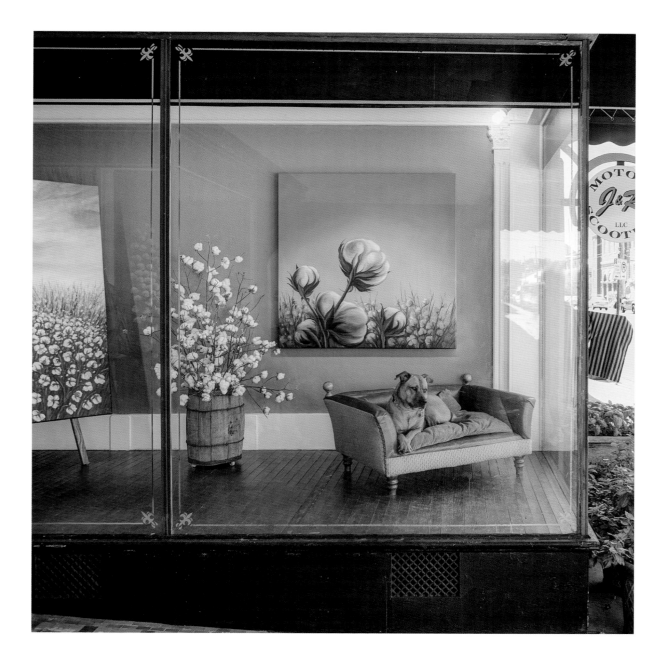

Liza Jane waits for her favorite nightclub to open. Most of the patrons think she's the hostess.

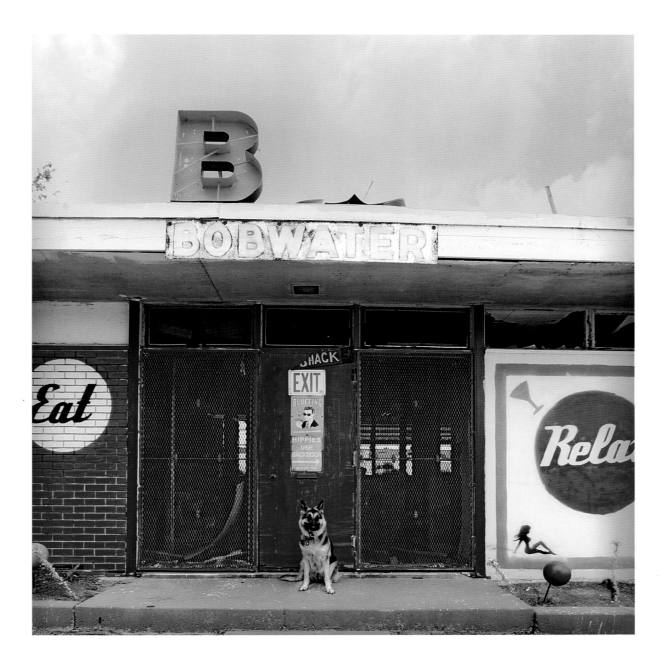

Shop Dogs

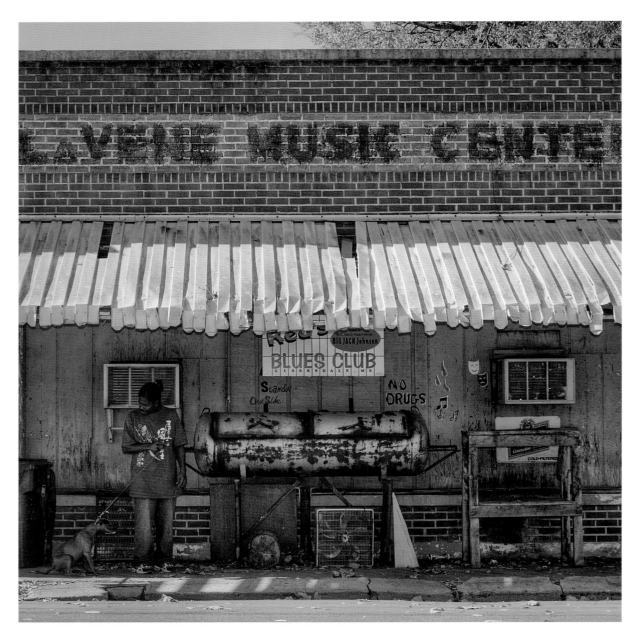

I met this puppy on Sunflower Street. She did not have time for formal introductions, preferring to stop and smell the barbecue.
CLARKSDALE, MISSISSIPPI

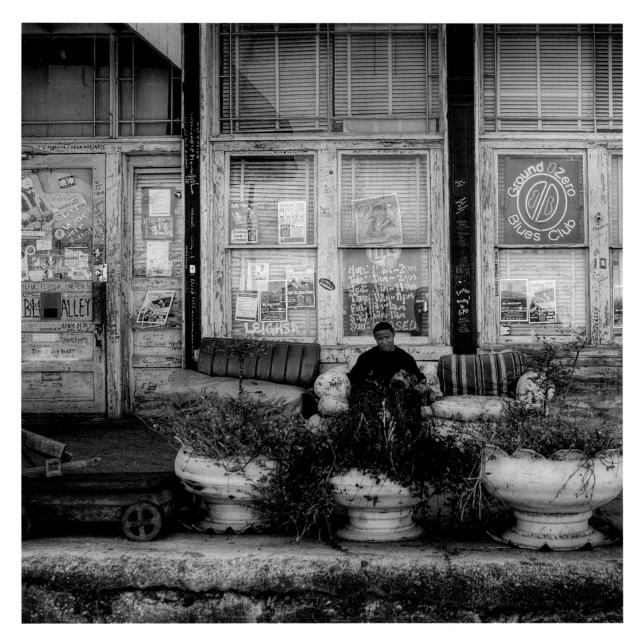

Gotcha takes a break at the birthplace of the blues. Delta blues founder Robert Johnson allegedly sold his soul to the devil a few blocks away.
CLARKSDALE, MISSISSIPPI

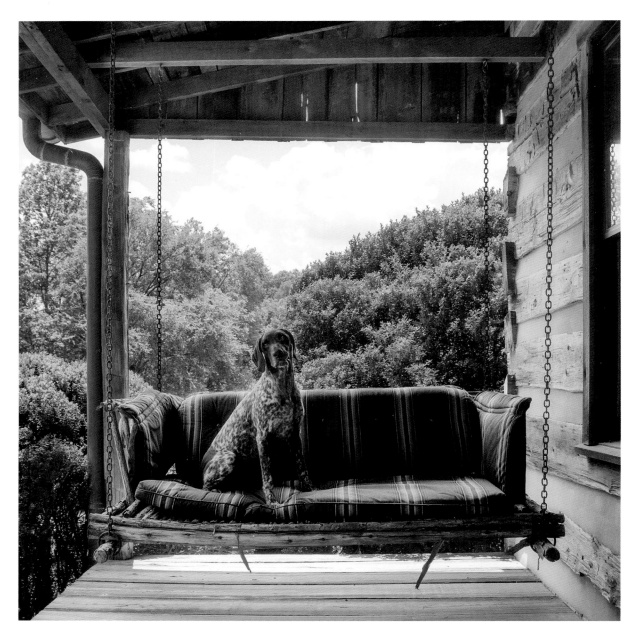

Memphis enjoys swinging out in the country. Lots of musicians play on this porch. Maybe a few will drop by today for a guitar pull.

HOUSE CIRCA 1795 / BINGHAM, TENNESSEE

Swing Dogs & Bench Dogs

Dogs avoid human feet by perching on porch swings and benches. They also enjoy the warm spots humans leave behind after they get up from sitting next to them. Swing and bench dogs are posers. They love to have their pictures taken.

Fancy shares the swing with Kai outside their favorite rare-book store.
HOUSE CIRCA 1881 / LEIPER'S FORK, TENNESSEE

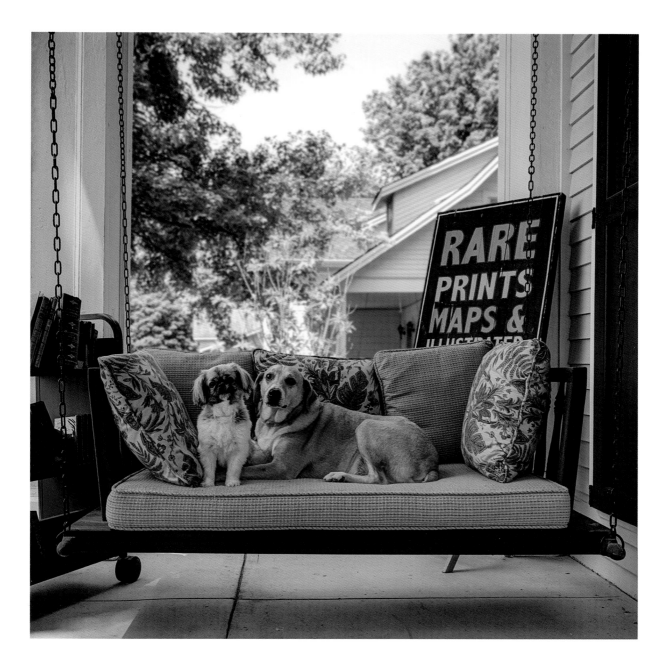

Swing Dogs & Bench Dogs

Rusty swings and whittles. Woodworking is fun. It produces lots of chew sticks.

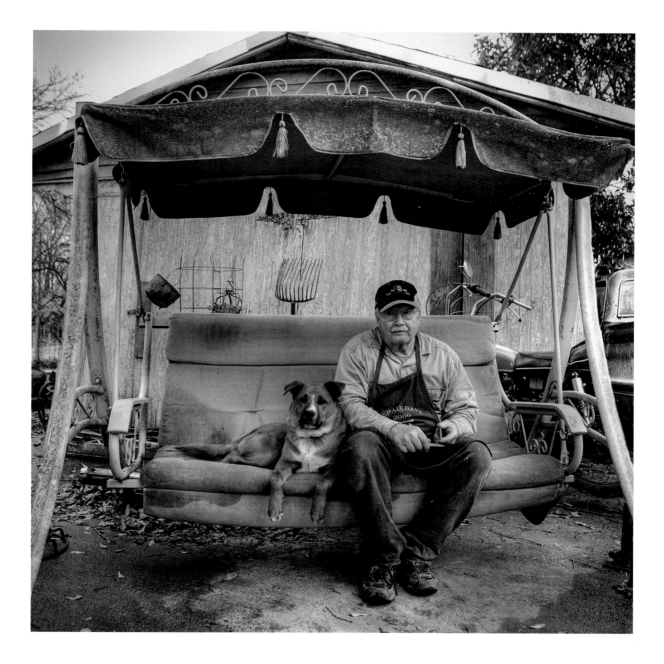

Swing Dogs & Bench Dogs

Dixie celebrates life so heartily that every day is Christmas at her home.
House circa 1912 / Memphis, Tennessee

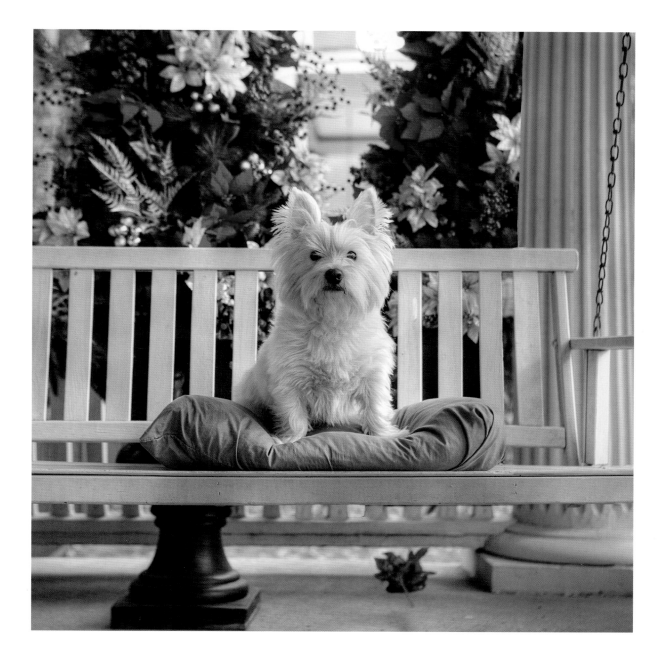

Swing Dogs & Bench Dogs

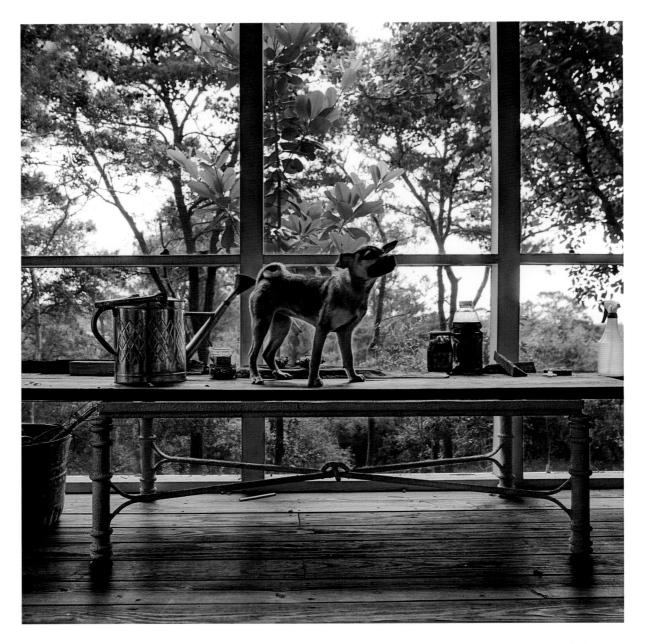

Ella jumps up on a bench to see what's going on in the backyard, a 300-acre nature preserve filled with forests, wild animals, oceanfront beaches, and a freshwater lake.
FOUR MILE VILLAGE, FLORIDA

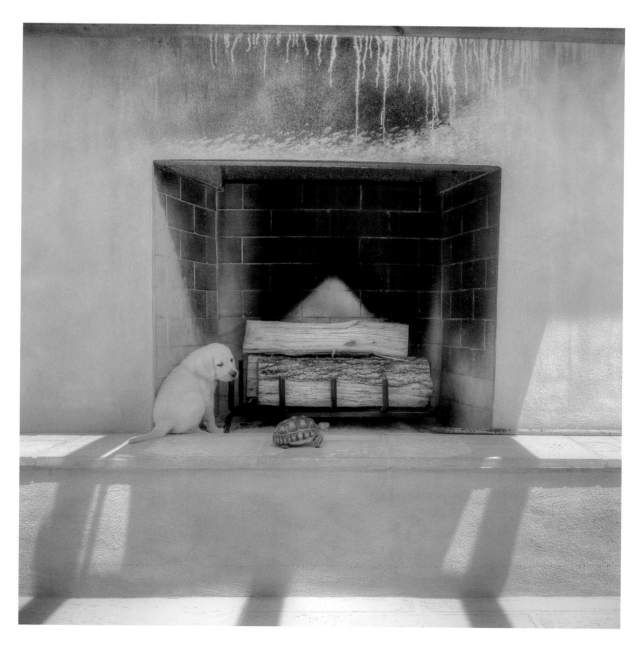

Lucky inspects Tiny the tortoise on an outdoor hearth.
POINT CLEAR, ALABAMA

Stella receives afternoon callers on her antebellum porch. Perhaps that special gentleman will come by today. Strangers are all so kind to her.

HOUSE CIRCA 1834 / HOLLY SPRINGS, MISSISSIPPI

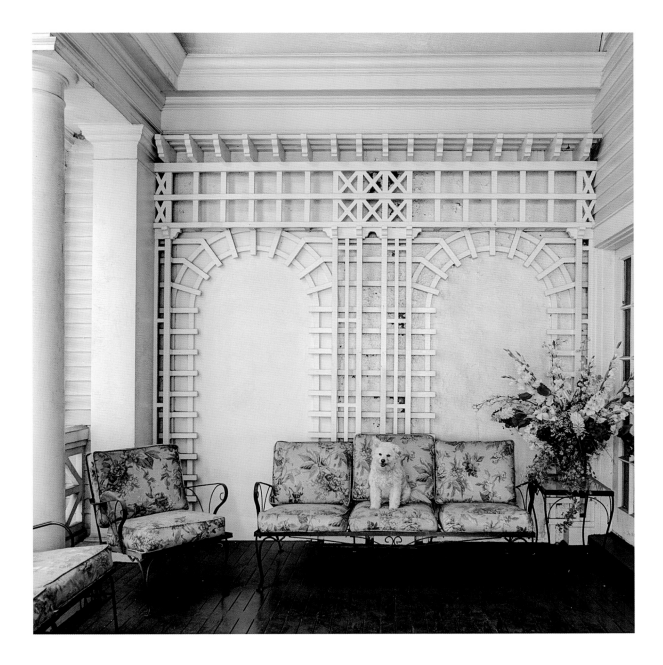

Gracie enjoys champagne and oranges while she swings.
HOUSE CIRCA 1914 / MEMPHIS, TENNESSEE

Swing Dogs & Bench Dogs

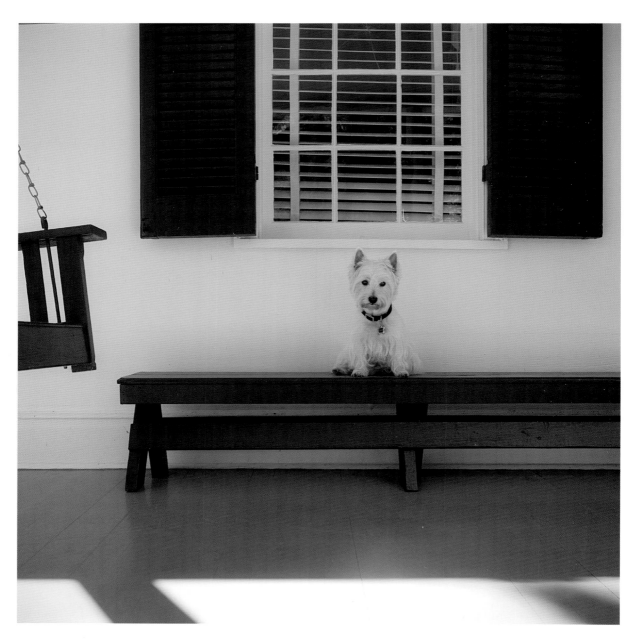

Sugar's porch is 80 feet long and runs the entire width of her house. Like so many grand homes, it served as a military hospital during the Civil War.
HOUSE CIRCA 1794 / NATCHEZ, MISSISSIPPI

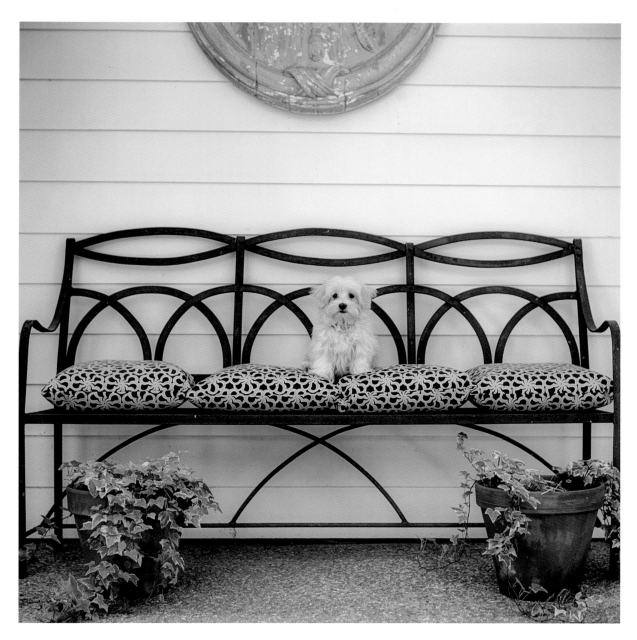

Everything is new to CeCe. She explores her home. The porch intrigues her with its smells and love.
MEMPHIS, TENNESSEE

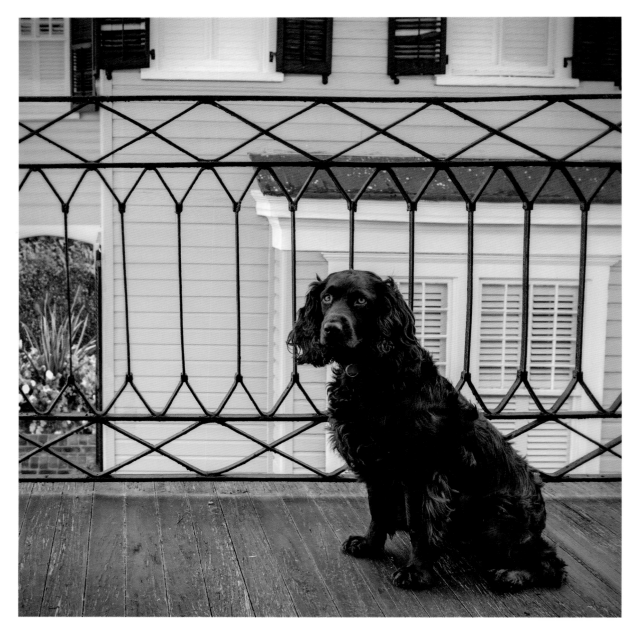

Pritchard's breed is the official state dog of South Carolina. She broadcasts the daily neighborhood news from her balcony.

House circa 1730 / Charleston, South Carolina

Top Dogs & Under Dogs

Balcony dogs are on top of their world. They see visitors coming from a distance and send out the alarm. This gives them the opportunity to communicate with their neighbor dogs. Balcony dogs have a lot to say.

Perhaps the smartest are the under-the-porch dogs. They have figured out that humans won't follow them under the house. The area under the porch offers sanctuary. It is the place for solitude (even dogs need time to themselves) and to have some peace and quiet. The sun does not like going under the porch either, so it's dark and cool there.

Corrie surveys the world from her second-floor terrace. From time to time, she wonders why she cannot fly.

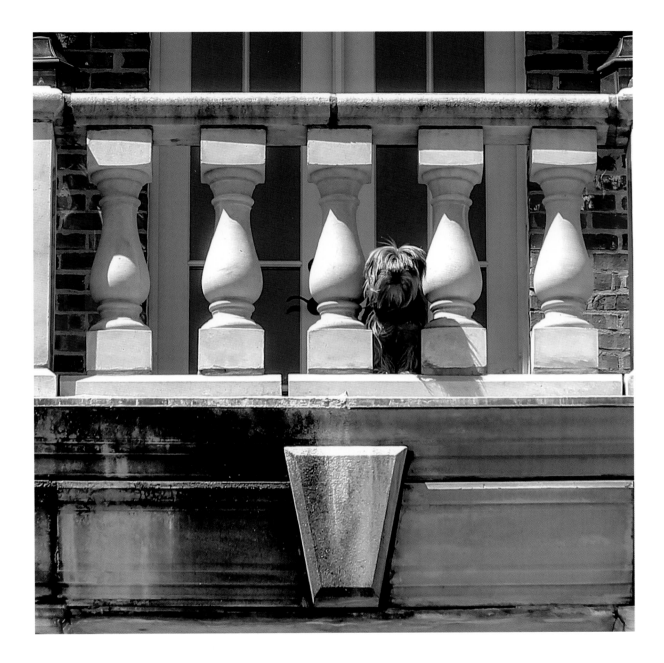

Lilly, Boo, Teasel, and Diva make up a chorus line of show dogs.
They "take five" on a bridge over a boulder-filled stream.
MEMPHIS, TENNESSEE

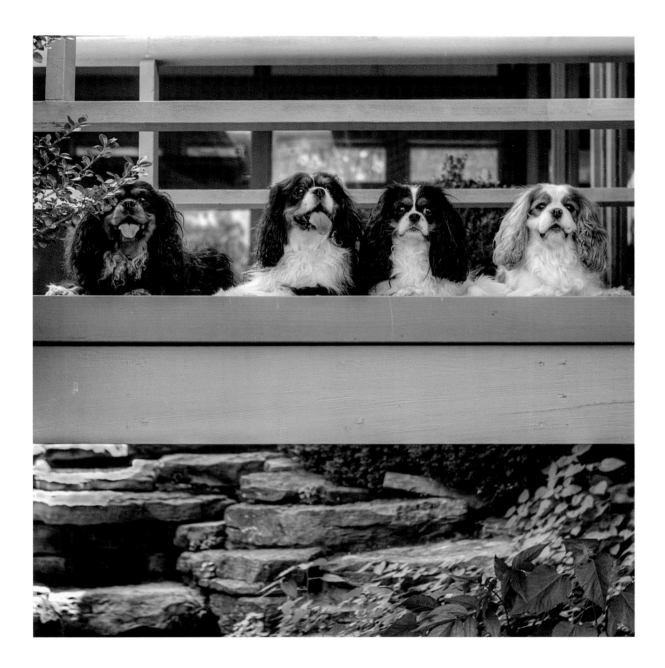

Ladybird hides under the porch to cool off. Her house was the set for the 1956 film *Baby Doll*.
HOUSE CIRCA 1859 (BEFORE RESTORATION) / BENOIT, MISSISSIPPI

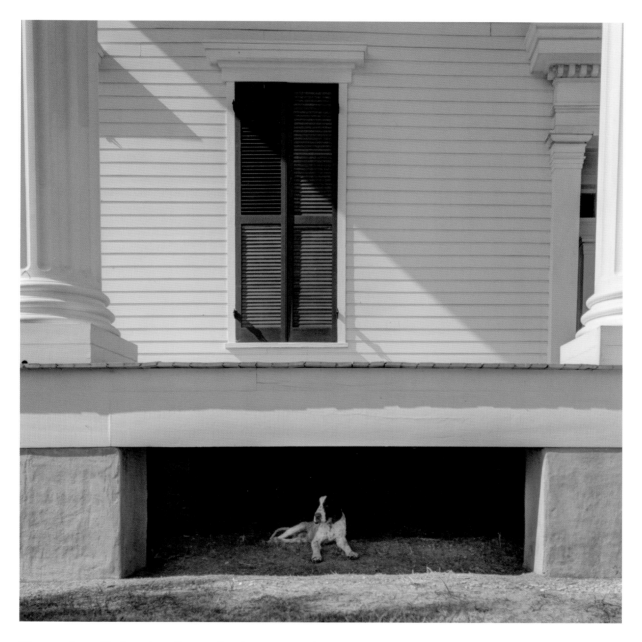

Six years later, Flash seeks refuge under the same porch.
House circa 1859 (after restoration) / Benoit, Mississippi

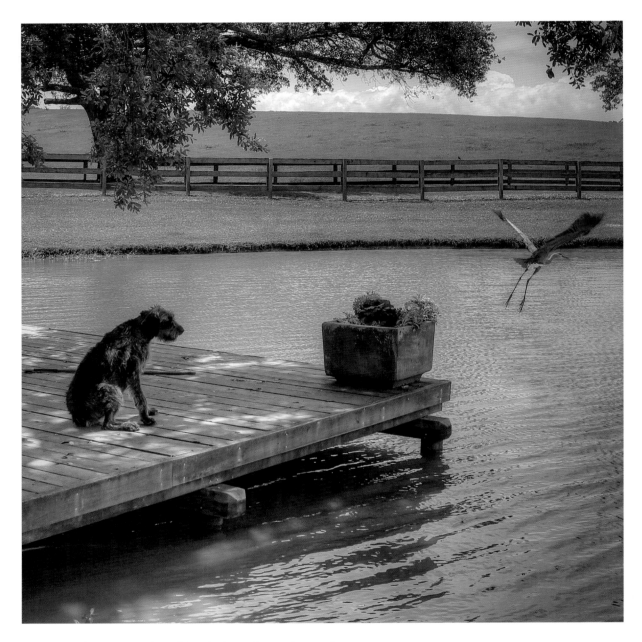

Freida watches a crane fly off the dock. Perhaps it's time for a swim.
Point Clear, Alabama

Dock Dogs

*I*f dogs could curl up and float on water, they would be in heaven. Unfortunately, they sink, so water dogs make a porch out of any place near anything wet—puddles, lakes, pools, etc. This makes it convenient to go boating, fishing, or swimming. Besides, something always needs retrieving.

Mika adores the lake, but she can't go swimming. A Florida alligator
prowls below her in the lily pads.
FOUR MILE VILLAGE, FLORIDA

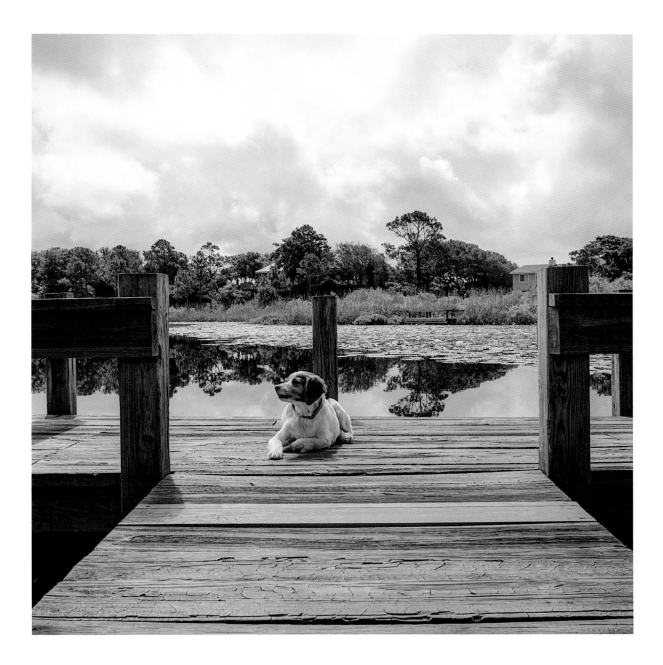

Dock Dogs

Luke ventures out on a cypress-filled lake to visit the wild ducks. He wants only to play with them. Maybe they won't fly away if he can float on the water like they do.

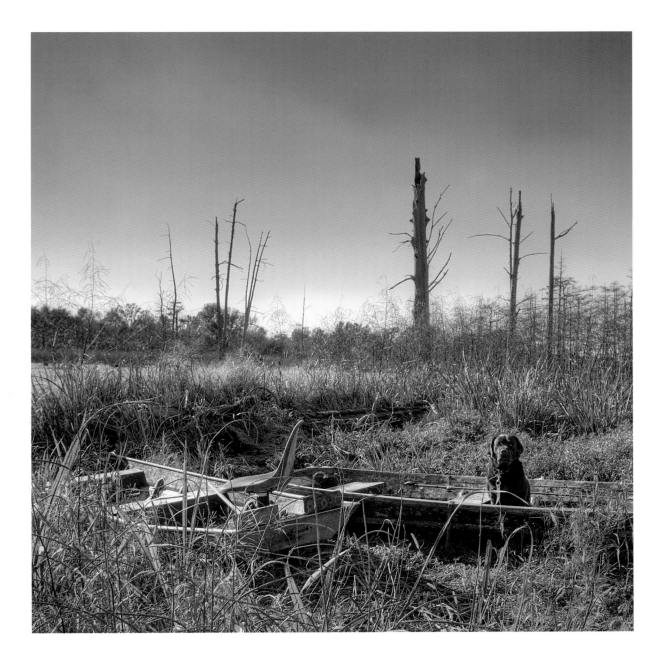

Dock Dogs

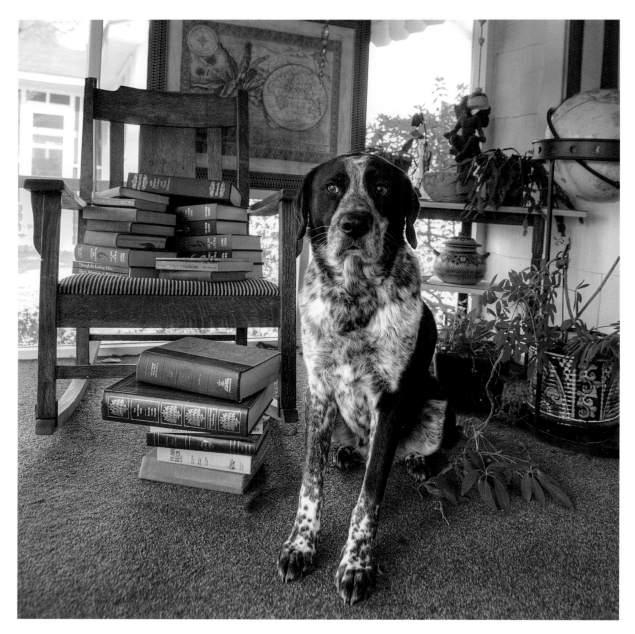

Ally loves books, but they don't taste as good as they smell.
JACKSON, MISSISSIPPI

Acknowledgments

*M*y deepest gratitude goes to the following collaborators for making *Porch Dogs* a success.

Agent: Anna Olswanger, Liza Dawson Associates

Photo editor: Maggie Kennedy

Foreword: Robert Hicks

Dog companions and permissions:

Evan Ballard
Wendy Barringer
Jennifer Baughn
Dawn Blackman
Rebecca Blackman
Kevin Brodeur
Mary and Grey Cane
Andrea Cooper
Mike Cotter
Jason Cotton
Randolph Cunningham
Jenny Dibenedetto
Kay and Jim Dickerson
Stuart Dixon
Shelley Durfee
Fred Emrick
Imogene Erb
Mary Ferguson
Suzanne Flohr
Conrad Goditus
Josh Haygens
Mark Henderson
Mary Louise Herndon
Robert Hicks

William Howard
Larry Hume
Pam Ireland
Jamie Kornegay
Gail and Jim Laughner
Jorja Lynn
Kevin Miers
Judy Morrow
Vince Musi
Alison Neumann
John Patten
Tres Patten
Lisa Reichert
"Sarge"
Martin Shea
Callie Shell
Odalia South
Olivia Stelter
Carroll Todd
Darren Trentacosta
Philippe Vander Elst
Michael Weatherly
Eustace Winn

Index of Photographs

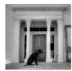

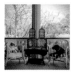
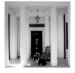

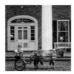

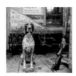
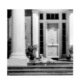

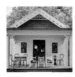
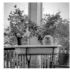
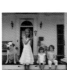

Index of Photographs

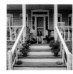

29 Daisy, a six-year-old female Springer Spaniel, on Sullivan's Island, South Carolina.

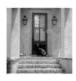

31 Harvey, a four-year-old male Labrador Retriever, in Point Clear, Alabama.

32 From left to right in Meansville, Georgia, are Gretel, a 10-year-old female German Shepherd; Lucy, a 12-week-old female Labrador Retriever mix; Oscar, a 13-year-old male mixed breed; Betsey, a seven-year-old female Labrador Retriever; and Scout, an eight-year-old female Labrador Retriever mix.

33 From left to right in Meansville, Georgia, are Oscar, a 13-year-old male mixed breed; Noble, a seven-year-old male Labrador Retriever mix; Bailey, a five-year-old male Chow Chow mix; Scout, an eight-year-old female Labrador Retriever mix; Train, a 10-year-old male Labrador Retriever; Gretel, a 10-year-old female German Shepherd; and Betsey, a seven-year-old female Labrador Retriever. Dinah, an 11-year-old female Labrador Retriever, is partially visible behind Scout and Train.

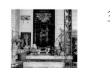

35 Teeny Baby, a 10-year-old female Yorkshire Terrier, in Natchez, Mississippi.

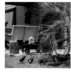

37 Barney, a thirteen-year-old male Basset Hound, in Memphis, Tennessee.

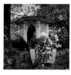

38 Randolph, a four-year-old female Maltese/Shih Tzu, in Magnolia Springs, Alabama.

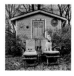

41 Muffin (*left*), a one-year-old female, and Biscuit, a one-year-old male—both Jack Russell Terriers—in Memphis, Tennessee.

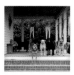

43 Gracie, a nine-year-old female Bedlington Terrier/Scottish Terrier/Whippet/Shar-Pei mix, in Memphis, Tennessee.

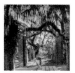

45 Oliver, a one-year-old male Welsh Corgi mix, on Cumberland Island, Georgia.

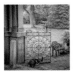
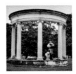
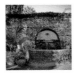
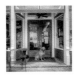
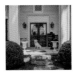
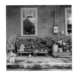

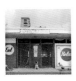
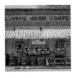
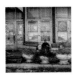
Index of Photographs

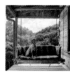

62 Memphis, a three-year-old female Deutsch Kurzhaar, in Bingham, Tennessee.

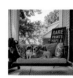

65 Fancy (*left*), a three-year-old female Pekingese mix, and Kai, a seven-year-old Labrador Retriever/Beagle mix, in Leiper's Fork, Tennessee.

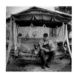

67 Rusty, a six-month-old male mixed breed, in Memphis, Tennessee.

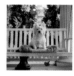

69 Dixie, a four-year-old female West Highland White Terrier, in Memphis, Tennessee.

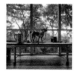

70 Ella, a five-month-old female mixed breed, in Four Mile Village, Florida.

71 Lucky, a seven-week-old male Labrador Retriever, with Tiny, an African Spurred Tortoise, in Point Clear, Alabama.

73 Stella, a five-year-old female Poodle/Jack Russell Terrier/Maltese mix, in Holly Springs, Mississippi.

75 Gracie, a nine-year-old female Bedlington Terrier/Scottish Terrier/Whippet/Shar-Pei mix, in Memphis, Tennessee.

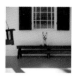

76 Sugar, a six-year-old female West Highland White Terrier, in Natchez, Mississippi.

77 CeCe, a 13-week-old female Havanese, in Memphis, Tennessee.

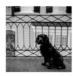

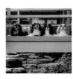
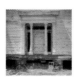
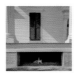
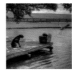
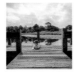

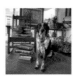

Index of Photographs

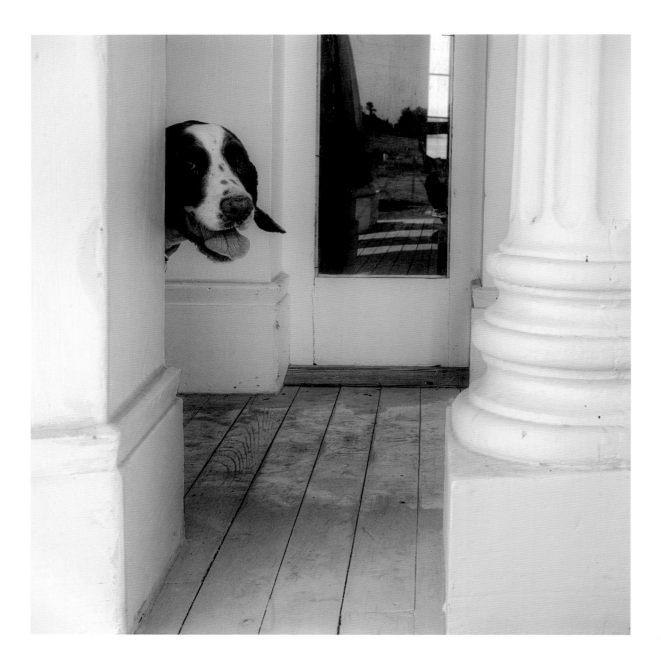